British Museum Objects in Focus

The Holy Thorn Reliquary
John Cherry

THE BRITISH MUSEUM PRESS

John Cherry has asserted the
right to be identified as the author
of this work

First published in 2010 by
The British Museum Press
A division of The British Museum
Company Ltd
38 Russell Square
London WC1B 3QQ

www.britishmuseum.org

A catalogue record for this book is
available from the British Library

ISBN 978-0-7141-2820-7

Designed by Esterson Associates
Typeset in Miller and
Akzidenz-Grotesque
Printed and bound in China
by C&C Offset Printing Co., Ltd

*To three scholars – Adam,
James and Matthew*

Acknowledgements
I am grateful to Jonathan Williams
for the invitation to write this book;
to Dora Thornton and James
Robinson for providing access to
the reliquaries, and to Dora,
especially, for her help on Baron
Ferdinand; to Saul Peckham for
photography, Axelle Russo for
ordering the photographs, Felicity
Maunder for editing; to Andrew
Burnett for support and
encouragement; and to Dominique
Delgrange, Marian Campbell and
Elisabeth Taburet-Delahaye for
helpful discussions.

Contents

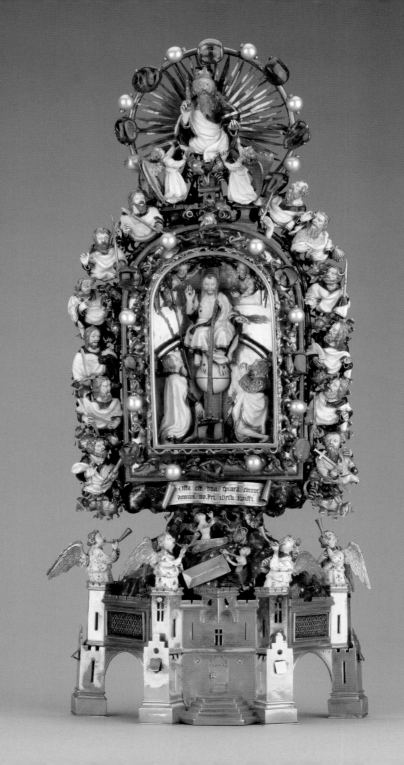

Introduction

The Holy Thorn Reliquary is a masterpiece of the goldsmith's craft, created at the end of the fourteenth century to house a single thorn from the relic of Christ's Crown of Thorns. The heraldry on the work shows that it was commissioned by a member of the French royal family, Jean, duc de Berry, son of John II, brother of Charles V and uncle of Charles VI. As a patron the duke had the resources to commission some of the finest castles, illuminated manuscripts and works of art. He was able to command craftsmen of great skill, including goldsmiths who could achieve remarkable miniature sculptures in gold and enamel. At a time when personal prayer and devotion, often stimulated by the possession of relics or pictures of saints, was seen as a way of avoiding sudden death and securing the salvation of those who had died, such riches were highly advantageous.

The relic of the Crown of Thorns was purchased in 1239 by St Louis (Louis IX, King of France), and became a symbol of the French kings and royal family. St Louis built the Sainte Chapelle in Paris to house it and other relics, while Jean, duc de Berry, created at the French city of Bourges his own Sainte Chapelle, with which the Holy Thorn Reliquary may have been linked.

In time the reliquary appeared in the Spiritual Treasury of the Habsburg emperors in Vienna, from where it was stolen in the mid-nineteenth century. It was later sold to the banker and collector Anselm von Rothschild, but neither he nor his son Ferdinand realized its significance. It came to the British Museum in 1898 as part of the magnificent Waddesdon Bequest, but it was not until the twentieth century that its true identity was discovered. In this book we will examine the meaning of the reliquary and tell the fascinating story of its survival and passage to the British Museum as an extraordinary example of the extravagance of French court patronage in the late fourteenth century.

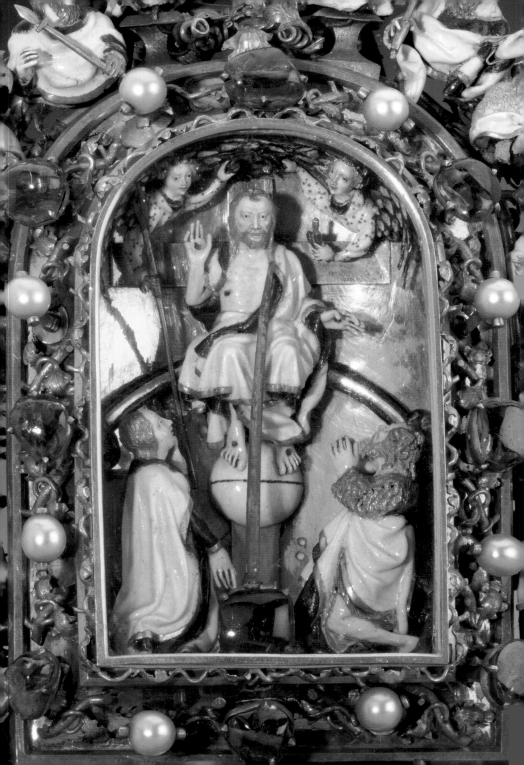

Chapter 1
The Sight of Salvation

The fascination of the Holy Thorn Reliquary lies in its setting of a religious vision amid sumptuous gold, enamel and jewels. Behind a crystal window, encompassed by pearls and rubies, Mary and John the Baptist look up at Christ, the Saviour of Mankind (Fig. 2). He is seated on a rainbow, displaying his wounds and raising his right hand to bless the thorn, which rises up from a huge sapphire. This vision of the Last Judgement does not show souls being divided between salvation and damnation, but rather the resurrection of the dead.

It is unclear whether the reliquary was designed for use within a chapel – perhaps the Sainte Chapelle at Bourges – or as a travelling reliquary. At over thirty centimetres in height, it can easily be carried by hand. The way in which such portable reliquaries might have been used can be seen in a manuscript illumination, probably of Jean, duc de Berry, kneeling before and looking upwards at a statue of Christ holding a white orb (Fig. 3). The reliquary will be described here as the duke might have looked at it.

The reliquary from the front
Kneeling before the reliquary, the eye is led from the base to the top. The base represents a castle with golden walls (see Fig. 1). Between two square turrets, a flight of five steps leads to a door secured by two massive horizontal bars and a square lock. The ground floor is defensible with closed shutters and long thin windows, which would have served as arrow loops. The upper storey has larger windows above the door and in the towers. The ownership of Jean, duc de Berry, is displayed by two panels of coloured enamel with heraldry: blue with many golden fleurs-de-lis within a red engrailed (indented with small concave curves) border ('*Azure semée de fleur de lis or within an engrailed border gules*'). The castle is one that belonged to the duke, but the gold walls may also represent those of the Heavenly City. Circular holes at the sides of the great door may have marked the setting for precious stones, now lost.

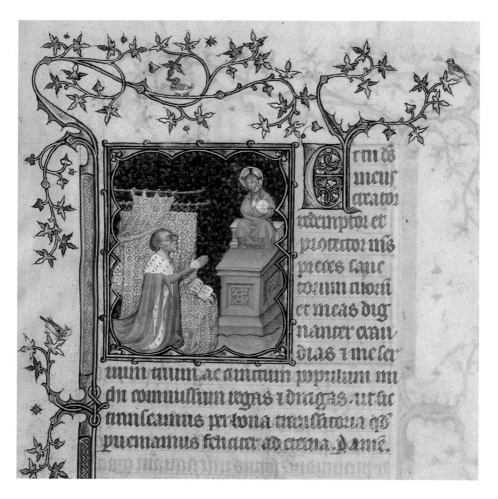



> cui dð
> meuf
> crator
> redēptor et
> protector nrs
> preces faue
> cozum aiorī
> et meas dig
> nāter aaū
> dias ı me ſer
> uium auim ac amuun populum ui
> di comunſtim regis ı dungas · ut ſac
> unnſeamus pr bona tranſitona qð
> pucniamus ſeliater ad cterna. þ amē.

In the turrets of the castle are angels blowing trumpets or curved horns, reminiscent of the trumpets sounded by the angels in the Book of Revelation to announce the Last Judgement. The angels, with golden hair and wings, are clad in blue-spotted white robes, two of which are decorated with blue fleurs-de-lis, perhaps as a symbol of France.

Next we reach a green hill, bespotted with red and white flowers and loops of wire that may have represented small trees. Here four coffins have been broken open, clearly with some force since their tops are turned over. From them rise

the dead. Four naked figures with white flesh – two women and two men – look upwards with their arms held outstretched in supplication, seeking salvation. The Resurrection of the Dead is linked in the Bible with the Day of Judgement: 'he hath appointed a day in the which he will judge the world in righteousness . . . whereof he hath given assurance to all men, in that he hath raised him from the dead' (Acts 17:31).

The top of the green hill marks the division on the reliquary between the earthly and the heavenly realms, just as the hill of Golgotha or Calvary marked the site of the Crucifixion. This boundary is marked by the inscription (titulus) on a scroll. Between three lines of white enamel are two lines of black enamel, which read:

Ista est una spinea corone
Domini nostri ihesu cristi
(This is a thorn from the crown
of Our Lord Jesus Christ)

4 The base of the Holy Thorn Reliquary showing the angels of the Resurrection and the arms of Jean, duc de Berry.

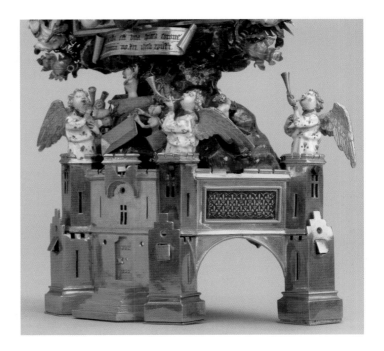

This emphasizes that Christ's crown was not made of rich gold and adorned with jewels but was a simple series of thorns bound together.

Surrounded by a frame set with eight rubies, eight pearls and golden foliage, the central scene of the reliquary lies behind a crystal window (see Fig. 2). Watching this scene from the two sides are the twelve apostles, headed by St Peter with his key on the right and, perhaps originally, St Paul on the left (the two upper figures on this side are later replacements). Beneath St Peter is St James the Greater, with his shell. Others can be identified by their symbols or attributes: St Andrew, one of the duke's patron saints, has his diagonal-shaped cross. Most of the apostles gaze at the central scene with expressions of surprise, wonder and admiration.

At the base of the central scene is a large square sapphire, held by four claws at the corners. The sapphire represents heavenly purity, recalling the Bible: 'They saw a vision of the God of Israel, and under his feet was something like a sapphire brick, like the essence of a clear blue sky' (Exodus 24:10). The thorn sits vertically in a gold grip behind this sapphire, which is held in place by a pin that goes through to the back.

On either side of the sapphire, on an enamelled ground with flowers, kneel the two intercessors present at the Last Judgement. To our left is the Virgin Mary, clad in a white gown with green fringes over a purple undergarment. The whiteness of the Virgin symbolizes purity, a point to which we will return. She points down towards the sapphire with her right hand. On our right St John the Baptist, clad in a white robe over his golden raiment of camel's hair, holds his hands together in prayer. Both look up at Christ, interceding on behalf of the resurrected souls.

From the sapphire rises a cross, which fills the back of the space behind the blessing figure of Christ and emerges above his head. Above the heads of the Virgin and the Baptist, Christ sits atop a rainbow of red, gold and green that emerges from clouds at either end. This signifies the throne of Christ's glory, mentioned in the Gospel of St Matthew: 'When the Son of Man comes in His glory, and all the angels

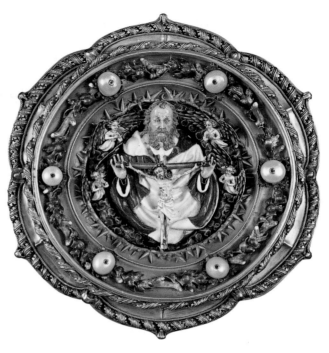

5 Morse with the Trinity.
France, c. 1400–10
(Trinity and angels),
1884–97 (setting).
Gold, enamel and
pearls, diam. 12.6 cm.
National Gallery of Art,
Washington DC

with Him, then He will sit on the throne of His glory' (25:31).
The interpretation of the throne as a rainbow comes from
the Revelation of St John: 'And immediately I was in the
spirit: and, behold, a throne was set in heaven, and one sat
upon the throne. And he that sat was to look upon like a
jasper and a sardine stone: and there was a rainbow round
about the throne, in sight like unto an emerald' (4:2–3).

At the top of the reliquary's central scene, two angels clad
in blue-spotted robes hold the Crown of Thorns over
Christ's head, along with three nails and a lance, symbols of
the Passion associated with the wounds in Christ's hands,
feet and side. These wounds displayed how Christ had
suffered for humanity, his sacrifice serving as the means of
redemption for the sins of mankind. Prominent at the
centre is Christ, clad in a white robe lined with green and
fringed with gold, who blesses the thorn, his feet resting on
a globe divided into three parts. Christ is not sitting in
judgement here; St Michael is not present to weigh souls or

11

divide the chosen from the damned. Instead Christ blesses, and displays his wounds, as he would at the end of time. To the chosen those wounds served as pledges of his love for them, to all sinners as a bitter reproach. He blesses the thorn set before him and, through it, all mankind.

A hole above the crystal capsule, between two angels, indicates the original position of a dove, which represented the Holy Spirit. The dove, which was almost certainly enamelled in white, flew out from the central point of the apex of the twelve apostles, midway between Christ and God the Father, ruler of all, above. In this way the reliquary alludes to the three-fold nature of Christ, or the Trinity. The Trinity is shown very clearly and most expressively in a white-enamelled morse or cope clasp in the National Gallery of Art in Washington DC (Fig. 5). Here God the Father and four winged angels emerge from clouds, all surrounded by a crown of thorns. He holds a cross carrying the crucified Christ and a dove flying downwards from the mouth of God to the head of Christ. This morse, perhaps contemporary with the reliquary, shows how the dove would have been depicted on that piece.

The reliquary from the back

The front of the Holy Thorn Reliquary invites the worshipper to contemplate the pain and sacrifice of Christ, signified by the relic of the Holy Thorn, and to seek redemption and pardon for their sins. The significance of the back is more difficult to appreciate since whatever was contained within was removed long ago. However, there is a striking contrast between the open display of the thorn and the depiction of the three figures of the Trinity on the front and the concealed nature of the back (Fig. 6). It is possible that the back was originally designed to be plain, and that its appearance as we now see it was the result of an alteration some years after the reliquary was constructed.

It may have been the case that, after contemplation of the front, the reliquary was turned so that the back could be opened and its contents revealed to the worshipper. Two angels trumpet their final call across the green flower-strewn hill, now empty of any tombs or signs of the resurrection.

6 The back of the Holy Thorn Reliquary.

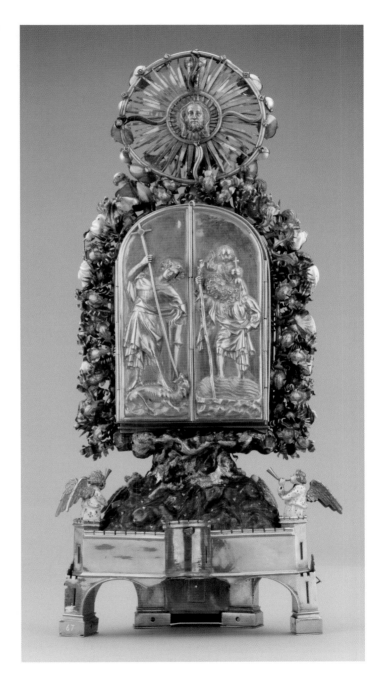

The eye is drawn upwards to two saints, whose full-length figures in relief fill the two outer doors of the low-arched frame, like the outer wings of an altarpiece (see Fig. 19). They are St Michael, whose wings are revealed by delicate stippling or pointillé decoration, and St Christopher, standing in water and carrying the Christ child on his shoulder. Both saints were concerned with the end of earthly life.

The Archangel St Michael is dressed in a long cloak, giving him a classical appearance, and slays the dragon with a lance held in his right hand, while with his left he supports himself on his shield. He has several associations. He was,

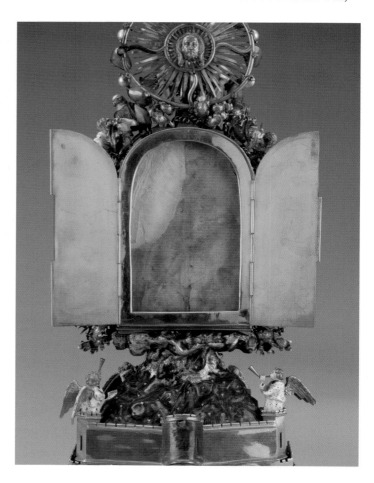

7 The back of the Holy Thorn Reliquary with wings open.

first, a symbol of God's power and providence, a saint of invincible goodness who was able to conquer demonic evil by fighting against Lucifer. In a more specific and worldly role he was the patron saint of the French monarchy. Lastly, St Michael weighed souls to decide their fate at the Last Judgement. He was the guardian spirit of boundaries between worlds and often featured in depictions of death. This role is the most relevant to the reliquary.

St Christopher, holding his staff in his right hand and hitching up his clothes with his left to avoid them getting wet in the river that he is crossing, stops to look up at the Christ child on his shoulders. Christ raises his right hand in blessing and holds the orb, now surmounted by a cross. This portrayal of St Christopher looking upwards at Christ shows a close relationship between the two. At the end of the Middle Ages it was a common belief that the sight of St Christopher would prevent the viewer from dying on that day without the last rites of the Church. Therefore both Christopher and Michael were associated with the final events.

After contemplating these two saints, the worshipper would have removed the gold pin from the central hinge that held the two wings shut, and opened them to revere whatever was displayed inside (Fig. 7). Alas, all that now remains is a flat layer of plaster, with a sheet of nineteenth-century paper or vellum in front of it. We do not know what the medieval viewer would have seen. It may have been an illumination or a piece of fabric, possibly covered by a very thin sheet of crystal.

A clue may be provided by the bearded face of Christ set above. The face, with long hair falling to either side, is set in the middle of points like the rays of the sun, which are themselves set within the circular framework that supports the stones on the front. It is possible that the relic contained behind the wings was a sheet of illumination or a piece of fabric showing the Veronica. This was a cloth supposedly belonging to a lady of Jerusalem, St Veronica, who accompanied Christ to his Crucifixion. When she used the cloth to wipe the sweat from Christ's face, his image was preserved upon it. St Veronica later travelled to Rome, where the cloth was displayed and publicly venerated.

The Veronica was one of the earliest images to have an indulgence attached to it. An indulgence is achieved through the recitation of a prayer or the viewing of an image, thereby gaining for the worshipper remission of time in Purgatory. In 1216, when the Veronica was being carried in procession through Rome, the image suddenly reversed itself. This led Pope Innocent III to compose a prayer in its honour, with an associated indulgence of ten days for each time that the prayer was recited. The Veronica became one of the key symbols of the Passion of Christ in the Catholic Church from the Middle Ages onwards.

Although the back of the reliquary has been described here by looking at the saints first, before opening the doors, the process may in fact have taken place in reverse. The worshipper might have viewed whatever lay behind the doors first, before closing them to look at the two saints: St Michael offering his protection and St Christopher assuring the worshipper of a safe passage through the day. It is interesting that the personal saints of Jean, duc de Berry – Andrew and John the Baptist – do not appear on the back of the reliquary.

The reliquary seen as a whole

The two sides of the Holy Thorn Reliquary present different aspects of visual worship. The open front displays the relic as a monstrance with a surrounding cast of figures. The back concealed an image or relic, protected by the closed doors on which the two saints stand. The contrast between the two sides is paralleled in a reliquary made around the same time from Chocques Abbey, Pas de Calais (Fig. 8). The suffering Christ, in white enamel with a large and gaping wound in his side, is held and presented to the viewer by a red-cloaked angel with painted wings. Beside Christ the open doors show the weeping figures of Mary and St John the Evangelist. Both have angels behind them, one holding the cross and the other the lance. In contrast to the front, the back shows the Ascension and Glorification of the Virgin Mary, and a small door, with the face of Christ, opened to reveal a relic. Like the Holy Thorn Reliquary, the front shows the suffering Christ, who has redeemed mankind through his Crucifixion, while the back concealed a relic.

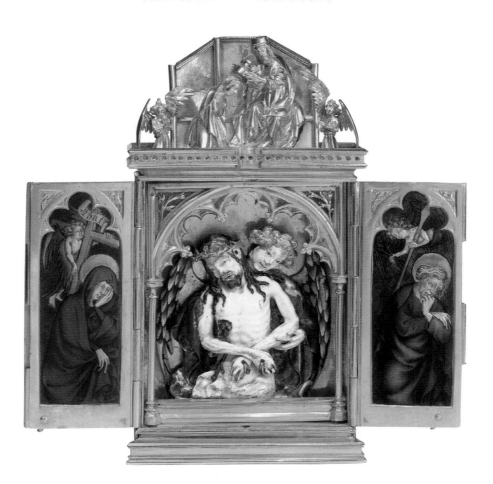

8 The Triptych Reliquary from Chocques Abbey, Pas de Calais. Paris, c. 1390–1400. Gold, with translucent and *en ronde bosse* enamel, H. 12.7 cm. Rijksmuseum, Amsterdam

It is not known whether the Holy Thorn Reliquary was used for private worship or for services in the church or one of the duke's chapels. The most likely context for its presentation is the Office of the Dead, which was sung at the funeral of a departed soul. Both the front and the back of the reliquary are concerned with the end of life. It may have had an amuletic quality, since it was important to repent of sin before death, to limit the time in Purgatory before admission to heaven. The reliquary enabled the worshipper to feel secure against the fear of death and might assure him of a safer passage into the world to come.

Annue nobis domine q̃ sumus ut sicut
beatus ludovicus confessor tuus in terris
tibi digne samulari meruit ita nos facias eius
apud te precibus adiuvari. p xp̃m dñm nr̃m.
Amen. Dñe exaudi oronem meam. Et cla
mor meus ad te veniat. Benedicam dño. Deo gr̃s.

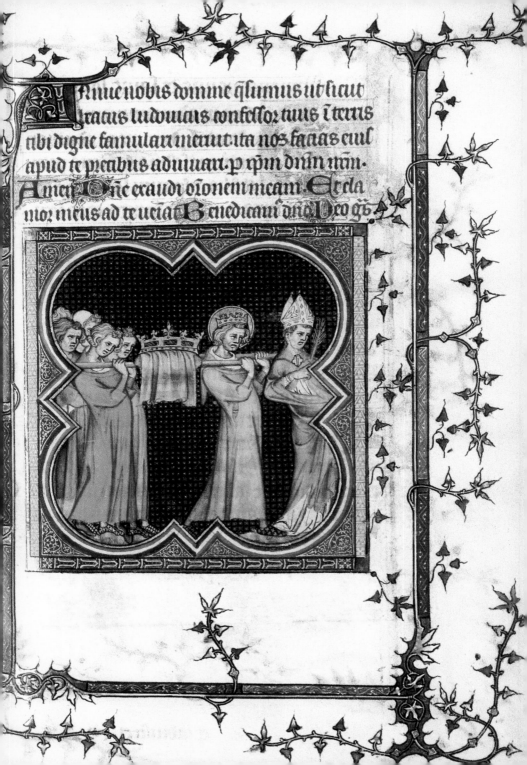

Chapter 2
The Crown of Thorns

The Latin inscription at the centre of the Holy Thorn Reliquary tells us that Christ is blessing a thorn from the crown that was set upon Christ's head as he was mocked before the Crucifixion. According to the Gospel of the Evangelist Matthew: 'The soldiers of the governor took Jesus into the common hall and gathered unto him the whole band of soldiers. And they stripped him and put on him a scarlet robe. And when they had plaited a crown of thorns, they put it upon his head and a reed in his right hand: and they bowed the knee before him saying, "Hail, King of the Jews"' (27:27–9).

The mocking of Christ and the Crucifixion took place in the year AD 30. Some three centuries later, Helena, mother of Constantine, the first Christian Roman emperor, discovered the relics of the True Cross in Jerusalem. On the site – the hill of Golgotha – she erected the Church of the Holy Sepulchre. This discovery led to the awareness of other relics, such as the Crown of Thorns. The Crown is first mentioned some time after 409, when Paulinus, bishop of Nola, near Naples, Italy, described how the desire to touch the places where Christ was physically present drew men to Jerusalem. Among other relics the column of his scourging, the thorns of his crowning, the wood of the Cross and the stone of his burial recalled Christ's former presence in the city.

Relics
Relics are objects associated with a holy person, often derived from their martyrdom or burial, which are venerated as a tangible memorial of the person. Relics were not worshipped in the Christian Church, but enabled the worshipper to recall and meditate on the life and suffering of the holy person. As St Jerome, a father of the Church, said: 'We do not worship, we do not adore, for fear that we should bow down to the creature rather than to the creator, but we venerate the relics of the martyrs in order the better to adore him, whose martyrs they are.'

While relics of martyrs or saints were valued, those relating to the life, suffering and death of Christ were the most prized in the Middle Ages. His foreskin, cradle and robe, the chalice used at the Last Supper, and relics of the Passion such as the Crown of Thorns, the Cross, stones from Golgotha and his burial shroud brought, through their physical proximity, the worshipping Christian closer to Christ and God. Those from the Passion and the Crucifixion were particularly prized, since it was through Christ's death on the Cross that mankind achieved salvation.

From early on, fragments of the True Cross and the Crown of Thorns were given as gifts: Paulinus of Nola was given a fragment of the Holy Cross by the bishop John of Jerusalem. Perhaps the most important was the gift made by the Byzantine empress Irene to Charlemagne of thorns from the Crown, while it was in Jerusalem. He deposited them in the church at Aachen, adding the lustre of Christ's crown to the man who was to be crowned Holy Roman Emperor in 800.

Since crowns symbolized ruling authority in the Middle Ages, the Crown of Thorns held particular significance and appeal for medieval rulers. After Caliph Omar entered Jerusalem in 638, the city was under Muslim control until it was captured in the first Crusade of 1099; by then the Crown of Thorns had been transferred to Constantinople. It was kept there in the palace chapel of the emperor rather than the great church of Hagia Sophia, thus strengthening the link between the Crown of Thorns and secular power.

St Louis

St Louis – Louis IX, King of France (r. 1226–70) – acquired the Crown of Thorns and a portion of the True Cross in 1239 from his cousin Baldwin II, the Latin Emperor of Constantinople. In desperate need of money, Baldwin had pawned the Crown to the Venetians, so Louis despatched two Dominicans to pay off the debt and secure the relic. In 1242 it arrived in Paris, where the Sainte Chapelle, a perfect example of Gothic architecture, was built to receive it. Completed in 1248, the chapel cost some 60,000 livres to erect. It was part of the Parisian royal

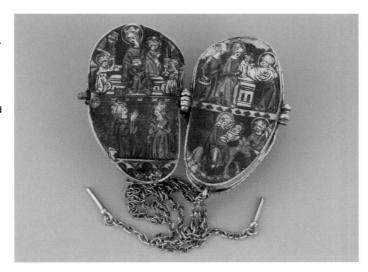

10 Reliquary pendant of the Holy Thorn, known as the Salting Reliquary. Paris, *c.* 1340. Gold and enamel, L. 3.8 cm. British Museum.
The top image shows two crowned figures praying to the Virgin and child, opposite the Circumcision and the Flight into Egypt; the lower image shows a leaf removed to reveal the thorn, opposite the Deposition and the Crucifixion.

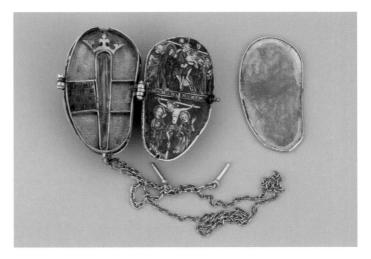

palace, meaning that the Crown had moved from one palace chapel to another. The purchase strengthened Louis's claim to be the leading king in Christendom; by acquiring for his capital the Cross and the Crown, the most prized of all relics, he not only showed great devotion but also asserted his political power (Fig. 9). In Paris Louis was trying to create a new Jerusalem.

What is the Crown of Thorns?

The relic of the Crown of Thorns was examined in the nineteenth century. It appears to have been a band of interwoven rushes (*juncus balticus*) with thorns called *zizyphus spina christi*, a type of buckthorn from the rhamnaceae family, commonly called the jujube tree, which grew quite widely around Jerusalem. The attachment of the thorns to rushes made it easy for the bishops of Jerusalem, and later for emperors and kings, to give individual thorns as gifts. Of those that survive today, small fragments of rush are preserved at Arras and Lyon, and thorns now at Trier and in the Capella della Spina at Pisa retain a particular characteristic of this shrub. The thorns grow in pairs, with a straight and a curved thorn commonly occurring together. However, the one in the Holy Thorn Reliquary and in a second thorn reliquary in the British Museum, discussed below (Fig. 10), are straight.

From the account of François de Mély (1904), it seems likely that, when the Crown was brought to Paris, its sixty or seventy thorns – many of which were given away by St Louis and his successors – had been separated from the band of rushes and were kept in a different reliquary. None of these thorns now remains in Paris. The Crown of Thorns was kept in the Sainte Chapelle until the French Revolution, after which it was deposited in the Cathedral of Notre-Dame in Paris. New reliquaries were created for it, one commissioned by Napoleon and another, Gothic in style, made to the designs of the great Gothic revival architect Viollet-le-Duc in jewelled rock crystal.

Many thorns said to be taken from the Crown were circulating in the Middle Ages; a fine reliquary pendant in the British Museum also contains one (Fig. 10). Probably dating from around 1340, this piece also has associations with the French royal family. Here the thorn is concealed rather than displayed. Set between two bean-shaped amethysts, this piece of jewellery was made to be handled, since it opens like a miniature prayer book. On opening, the first leaf shows two crowned figures – possibly Philip VI and his queen, Jeanne de Bourgogne – praying beneath the Virgin and Child, opposite the Circumcision and the Flight into Egypt. If the central leaf is held at ninety degrees to the first scene, they are also praying

11 Etienne Martellange, *View of the Sainte Chapelle of the Palace at Bourges*. 1615. Bibliothèque nationale de France

to the Deposition and the Crucifixion on the last leaf. The central leaf has the Adoration of the Shepherds painted on vellum, under a crystal cover. Only when this is removed can the thorn be seen, an act of discovery very different to the open display of the thorn in the Holy Thorn Reliquary. The thorn is encased in crystal with a crown above. Surrounding it were seven panels, one of which has survived and reads *'de spina sancte corone'* ('thorn from the holy crown').

Many members of the French royal family treasured such thorns, given to them by St Louis, and in the second half of the fourteenth century several of them built Sainte Chapelles of their own. In 1388, after Charles VI had conferred on Jean, duc de Berry, the sovereignty of Auvergne, Jean erected a Sainte Chapelle at Riom (Puy de Dôme). Later, in 1392, he built a Sainte Chapelle for his palace at Bourges, where his funerary monument was to be erected (Fig. 11). Both were modelled on the architecture of the Sainte Chapelle in Paris.

23

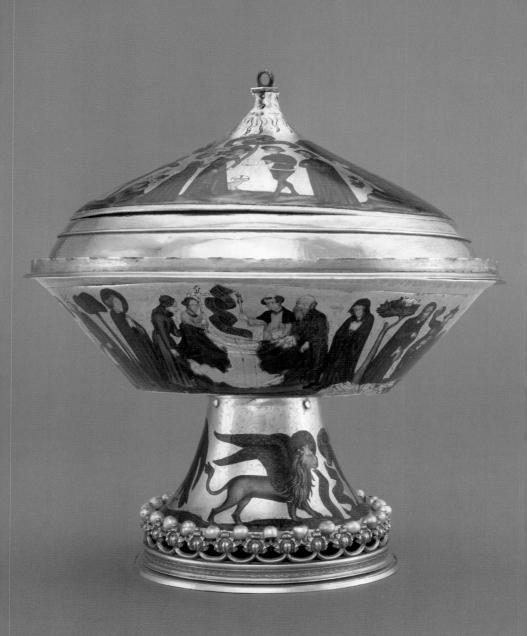

Chapter 3
The goldsmith

Paris was the most important centre in fourteenth-century Europe for artists and craftsmen. Many excellent goldsmiths were based there, some of whose names are known to us: Hennequin du Vivier was Charles VI's goldsmith from 1382 to 1390, and Hermann Ruissel worked for the Duke of Burgundy from 1385 and later for Charles VI. Some names, such as Hans Karast, goldsmith to Louis, Duke of Orleans, suggest a strong influence from the Rhineland or the Netherlands. None can be linked with surviving pieces of goldsmith's work in the way that manuscripts can be linked with illuminators.

The Royal Gold Cup

The finest surviving piece of Parisian fourteenth-century goldsmith's work is the Royal Gold Cup (known in French as the Coupe St Agnes), also commissioned by Jean, duc de Berry, and now in the British Museum (Fig. 12). This standing gold cup, known as a hanap, is richly decorated in translucent enamel with scenes from the life of St Agnes. It is thought that Jean commissioned the cup as a gift to his brother Charles V, who was born on 21 January, the feast day of St Agnes; this would explain its iconography. Charles's sudden death in 1381 meant that the cup was never presented to him. Instead it was given by the duke to Charles VI, Charles V's son, as noted in the king's inventory: '*Et donna ledit hanap et couvercle au Roy Monseigneur De Berry au voyage de Touraine l'an 91*' ('And the said hanap was given to the King by my Lord of Berry on his visit to Touraine in 1391'). The colours achieved in the cup – reds, blues and greens – are amazing. There is also a tiny area of white enamel, used on a level surface, for the background of the jewel casket held out by St Agnes's suitor.

The Royal Gold Cup may have been intended for use as a ciborium (a container for the host), which would make it a more liturgical object than the Holy Thorn Reliquary. This could explain why the host is shown so prominently in a roundel inside the bowl of the cup (Fig. 13). Christ with halo

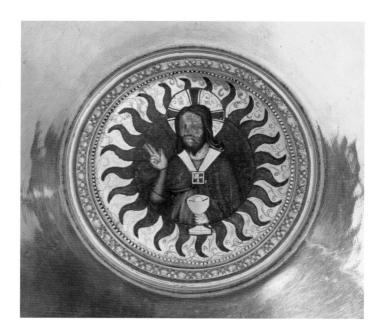

emerges from a flaming red star, blesses and presents the chalice and host, a sign of Christ's sacrifice commemorated in the Eucharist.

Émail en ronde bosse

The technique known as *émail en ronde bosse* (white enamelling in the round) was developed and practised in the fourteenth century by goldsmiths in Paris, and constitutes the covering of gold surfaces with white opaque enamel, in which lead forms a major component. The technique was particularly used for small-scale sculptures, initially for animals and birds and later for figures; it can be seen on the swan jewel found at Dunstable in Bedfordshire, England, on which white enamel covers the gold of the bird's body and wings, red enamel is used for the beak and black enamel for the legs (Fig. 15). When the Royal Gold Cup was made around 1370–80, white enamel was already known. In 1367 a Paris goldsmith, Vincent de Couloigne (Köln), was paid to make a gold belt with enamelled white eagles and swans for the son of the Duke of Burgundy, but we do not know whether these were in the round.

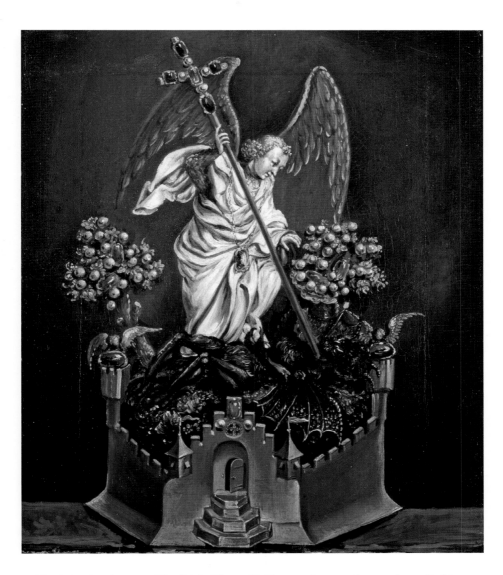

14 Oil painting showing a statue of St Michael killing the dragon. Bavarian, 19th century. Bayerisches National-museum, Munich. The statue was given on 1 January 1397 by Philip the Bold to Charles VI.

The Holy Thorn Reliquary is one of a number of white-enamelled works dating from the period around 1400. Considering others will enable us to see it in context. The earliest securely dated white-enamelled sculpture was a statue of St Michael. Although it no longer exists, it is recorded in a painting dating from the early nineteenth century (Fig. 14), when the statue was in the church of Our

15 The Dunstable Swan Jewel. France or England, *c.* 1400. Gold and *en ronde bosse* enamel, H. 3.3 cm. British Museum

28

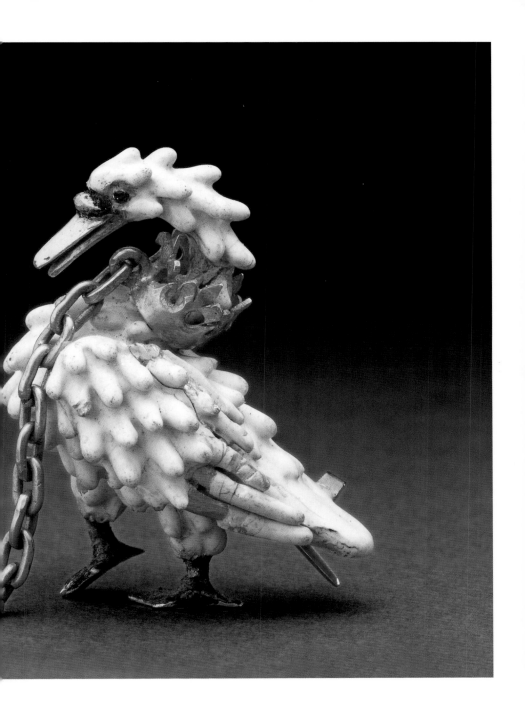

Lady at Ingolstadt in Bavaria, to which it had been given in 1441 by Louis, Duke of Bavaria. We know that the statue was made before 1 January 1397, because on that day it was given by Jean's brother Philip, Duke of Burgundy, to Charles VI, Jean's nephew. A very striking piece, it showed St Michael in a white robe killing a dragon with a lance topped with a bejewelled cross. The scene is enacted in a castle with crenellated walls, steps and towers, in which angels stand holding sapphires, all reminiscent of the Holy Thorn Reliquary. It takes place on a green terrace, from which rise trees laden with pearls and precious stones, perhaps a feature of Paradise, also recalling the reliquary. The Holy Thorn Reliquary and the statue of St Michael are probably contemporary Parisian works.

A work dating from 1380–90, now in the Musée du Louvre, Paris (Fig. 16), depicts the Trinity, as does the Holy Thorn Reliquary. God the Father in the centre would have held a cross carrying the body of Christ, beneath a dove. Above is a figure of Mary, who may have held Christ's body, and above her a figure of the risen Christ. All these figures are rendered in quite crude white enamel, a result of the overheating of the furnace in which the enamel was fired.

Other white-enamelled works, such as the triptych with the suffering Christ from Chocques Abbey (see Fig. 8), invite contemplation on the Passion of Christ. This piece includes white and translucent enamel of the highest quality, and some of the finest pointillé work on the back, but lacks any precious stones. The suffering Christ also appears on the front of a reliquary in Montalto, Italy (Fig. 17), as a full-length figure supported by an angel. Christ's flesh is pink against his white robe. He is flanked by circular panels of the Crucifixion and Flagellation on either side, and the Entombment of Christ beneath. God the Father is above, set amid four angels bearing precious stones. The green ground on which the angels bearing the lance and the column kneel is very similar to that of the Holy Thorn Reliquary. Originally, the Passion of Christ would have been emphasized on the Montalto reliquary by a depiction of the Agony in the Garden of Gethsemane on the back.

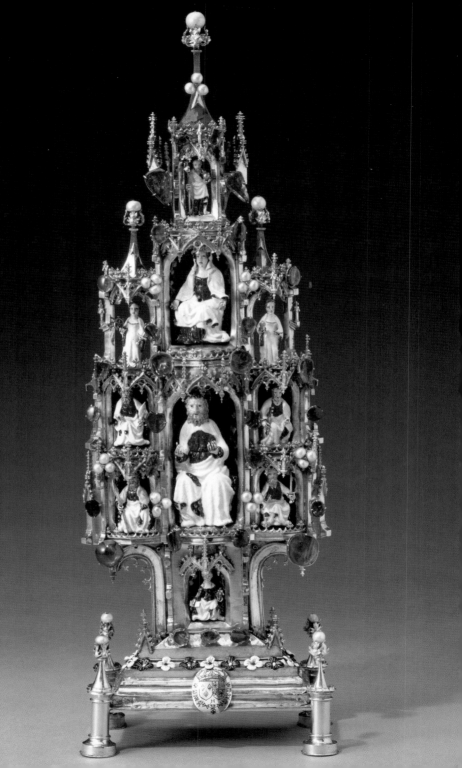

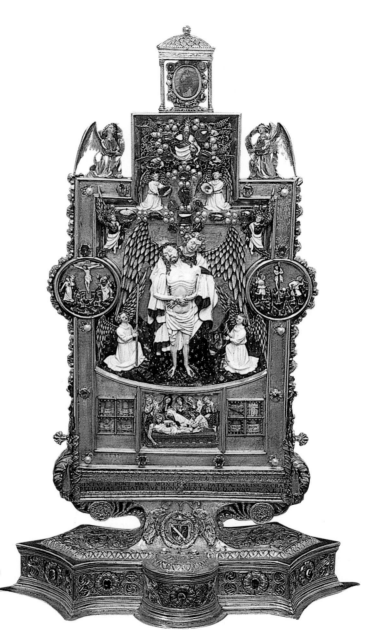

17 The Montalto
Reliquary. Paris, c. 1400.
Gold, enamel and silver
gilt, H. 70 cm. Museo
Sistino Vescovile,
Montalto, Marche, Italy.
First recorded in the
inventory of Frederick II,
Duke of Tyrol (d. 1439),
the reliquary was later in
the possession of
Cardinal Pietro Barbo,
who modified both the
top and the base.

The cult of white Madonnas

While Jean, duc de Berry, for whom the Holy Thorn Reliquary was made, held a particular devotion to the subject of the Passion of Christ, he also had a great enthusiasm for images of the Virgin, either standing or seated: twenty-six depictions of the Virgin and child in different materials are recorded in his inventory of 1403. Two such pieces of goldsmith's work have survived. One is an exceptionally fine small black and white enthroned Madonna in Burgos Cathedral in Spain, given by Jean to the Queen of Castile. The body is carved from jet while the head and the Christ child are carved in ivory. The second is a seated Virgin and child in white *émail en ronde bosse*, now in Toledo Cathedral in Spain, given by the duke to the Queen of Navarre before 1403. Although the colour worn by the Virgin traditionally was blue, there was a cult of white Virgins, for which the enamel on gold was particularly appropriate.

The finest Madonna in white enamel is preserved at Altötting in Bavaria (Fig. 18). This was presented as a New Year's gift in 1405 by Isabeau of Bavaria to her husband, Charles VI, but, alas, was pawned that same year to pay the arrears on the sum pledged to Isabeau's brother, Louis of Bavaria, for his yearly pension and his wedding to Anne of Bourbon. The piece is a goldsmith's tour de force in gold, silver and silver gilt. It shows a white Virgin in miniature, before whom kneel the figures of Charles VI and his queen, who appear like actors in a play. The theatrical quality of the work is enhanced by the way in which the action is set on two levels: beneath the devotion a groom dressed in particoloured hose holds a horse with realistic head and delicate saddle, which gives the piece its popular name of the *Goldenes Rössl* or Little Golden Horse. Another example of a Madonna in white enamel was a statue from Ingolstadt known as *Die Gnad*. Formerly in the collection of Charles VI, it suffered the same fate as the statue of St Michael and is also now only recorded in a painting.

Making the reliquary

The Holy Thorn Reliquary carries some of the finest white enamelling to survive. Like the other pieces illustrated here, it plays on the use of white enamel for symbolic as well as decorative purpose. In the Book of Revelation, white is both the colour of purity and of salvation: St John the Divine wrote that 'he that overcometh, the same shall be clothed in white raiment' (3:5). This is reflected on the reliquary.

Enamelling *en ronde bosse* required the goldsmith to be a sculptor in miniature. Working with gold plate and wires of many different thicknesses, great skill had to be used to create an often complex base structure, and the goldsmith had to attend to the way a work was composed and balanced. It is noticeable that the cutting out of the base at the back has unbalanced the Holy Thorn Reliquary.

Where it was not enamelled, the surface of the gold was either left plain, as on the walls and towers of the reliquary, or, as on the back, it was raised in relief or decorated with pointillé work. The figures of St Michael and St Christopher are depicted in relief (Fig. 19). St Michael in particular twists his body in a soft flowing style, which recalls the decoration on the sceptre of Charles V, made before 1380 and now in the Musée du Louvre in Paris. The contrast between the two figures and the stippled punched work (pointillé) of the background is a fine example of goldsmith's work. Pointillé is a technique borrowed from miniature painters, and is used here to simulate the brocades worn by the two saints and the delicate feathery quality of Michael's wings.

As we shall see in the next chapter, Jean, duc de Berry, was fascinated by precious stones, and he would have indicated how many were to be used on the reliquary. The most numerous are the pearls, which are associated with Christian virtues and symbolize purity. In Jan van Eyck's altarpiece of the *Adoration of the Mystic Lamb* in Ghent (completed 1432), the main figures wear rich robes trimmed with pearls in intricate designs and crowns studded with pearls. Around the side of the reliquary's frame, the pearls alternate with rubies, thought to be the most precious of stones, the gem of gems, which surpasses

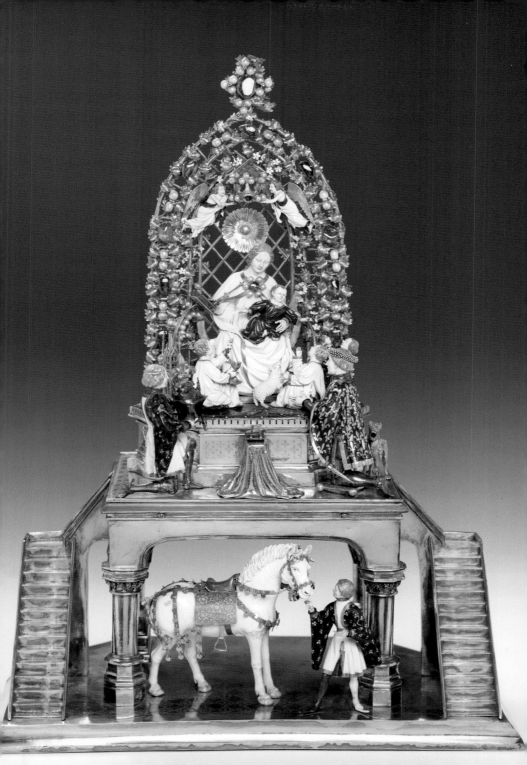

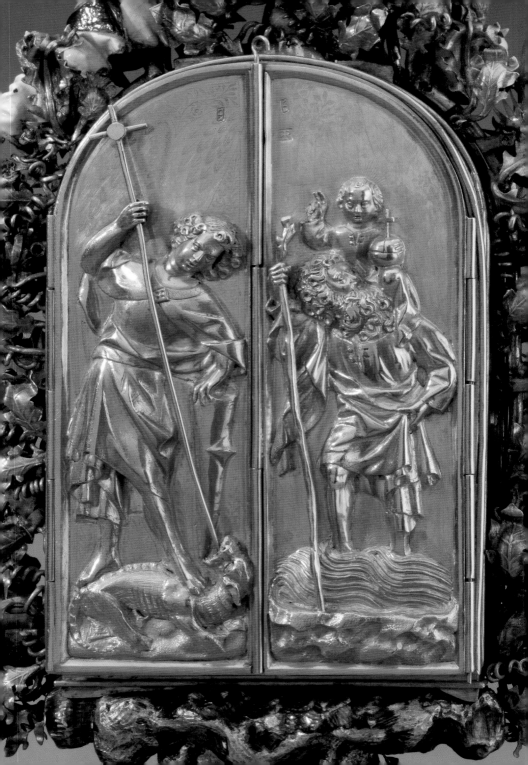

19 The figures of
St Michael and
St Christopher on
the doors at the back
of the Holy Thorn
Reliquary.

all other stones in virtue. In the *Divine Comedy* Dante used the ruby as a symbol of divine joy.

The reliquary's central scene of the Second Coming is covered by crystal, perhaps echoing Revelation 4:6: 'And before the throne there was a sea of glass like unto a crystal'. Crystal is often used to cover relics. The ninth-century Talisman of Charlemagne was composed of two crystal hemispheres enclosing portions of the True Cross and the Hair of the Virgin. In the Salting Thorn Reliquary (see Fig. 10), the thorn is encased in a tube of crystal. Aside from being clear, crystal was supposed to have magical qualities.

Pride of place on the Holy Thorn Reliquary is given to the two sapphires, one beneath the thorn and the other placed at the top of the reliquary. One of the twelve stones in the foundations of the Heavenly City in St John's apocalyptic vision, the sapphire was also a favourite stone for bishops' rings and a symbol of purity. The presence of a sapphire above the head of God the Father in the Trinity on a remarkable mid-fifteenth-century devotional gold jewel found at Middleham in Yorkshire indicates that it may have represented heaven.

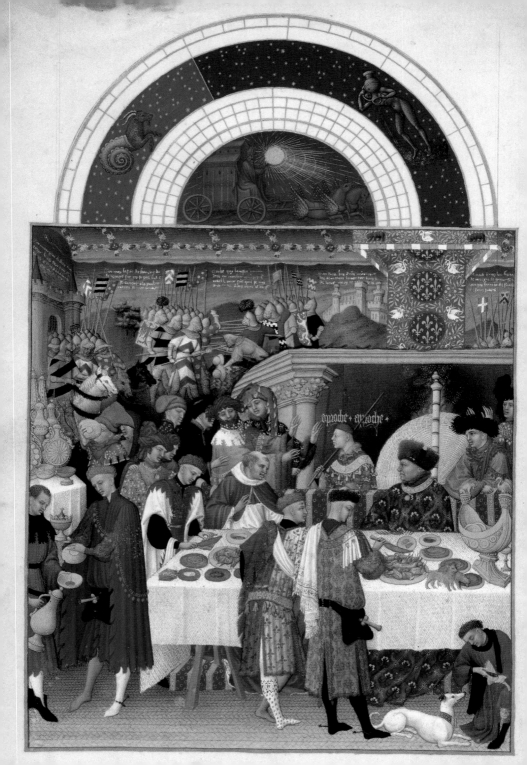

Chapter 4
Jean, duc de Berry

The castle walls of the Holy Thorn Reliquary carry rectangular panels enamelled in blue and red with heraldic arms, '*Azure semée de fleur-de-lis or within an engrailed border gules*' (blue with many golden fleurs-de-lis within a red engrailed border; Fig. 21). Gold fleurs-de-lis on a blue field were the arms of the kings – and hence the realm – of France from the twelfth century. The engrailed border in red indicates that these arms can only relate to the third son of the French king John II (the Good), who ruled from 1350 to 1364. That son was Jean, duc de Berry.

The French royal arms are a reflection of events that were to have a great influence on Jean's life, namely the wars between England and France, often known as the Hundred Years War. After the death of Philip V, the last Capetian king of France (r. 1316–22), the crown had passed to his nephew Philip VI (r. 1328–1350), of the Valois family. The end of direct succession led Edward III, King of England (r. 1327–70), to claim the throne of France through the marriage of his father, Edward II, to his mother, Isabella, daughter of Philip IV of France (r. 1285–1314). On claiming the throne in 1340, Edward III quartered the lilies of France with the lions of England, a motif that survived on the English royal arms until 1801. More was at stake than simple dynastic succession, since the dispute broadened into how far the English could rule in France. The wars lasted, with gaps, until the defeat of the English by Joan of Arc in the mid-fifteenth century.

Born on 30 November 1340 (St Andrew's Day), Jean was six years old in 1346, when the English won the battle of Crécy; and sixteen years old in 1356, when the English, under Edward the Black Prince, won the battle of Poitiers and captured Jean's father, John II, who was imprisoned in the Tower of London.

Jean was the third of four brothers. His eldest brother, Charles, succeeded to the French throne in 1364 as Charles V (the Wise). The next brother, Louis, was made Count of

Anjou and Maine in 1356. The youngest brother was Philip, called 'the Bold' because, aged fourteen, he stood beside his father against the English at the battle of Poitiers. In 1363 Philip was invested with the Duchy of Burgundy. Under the system of appanages, in which estates or titles were granted to the younger children of the monarch, Louis, Jean and Philip exercised powers as the royal lieutenants in the areas of Anjou, Berry and Burgundy respectively. The appanage for Jean was created in 1356 by the grant of Poitou, to which was added Languedoc in 1380, and in 1402 he was named lieutenant for life in Berry and his other lands, where he exercised virtually all the powers of a sovereign. His capital was the city of Bourges, where he had two palaces and his administration, and where he created his own Sainte Chapelle.

Eight years old at the time of the Black Death, during which he lost his mother, Jean was twenty-four when his elder brother succeeded to the throne as Charles V. Charles recovered much of the land ceded to England after the Treaty of Brétigny in 1360; his early death in 1380 at the age of forty-two was a tragedy for France. He was succeeded by his fourteen-year-old son, Charles VI (b. 1368). Louis of Anjou died in 1384, leaving Jean as the eldest surviving brother. His younger brother, Philip, died in 1404, when Jean was sixty-four years old. Thereafter Jean played a significant role, as he tried in vain to secure peace between the Orleanist and Burgundian factions. As a prominent member of the French royal family, Jean had considerable political importance, and served as Regent of France during the minority and madness of Charles VI.

Jean married twice, to Jeanne d'Armagnac and Jeanne de Boulogne. Of his children his two male heirs died before him: Charles de Berry in 1383 and Jean, Count of Montpensier, in 1397. After then he had no heir, and there was no likelihood that his wife would produce one. The prevalence of death around him may have led Jean to concentrate his energies on his own commemoration.

Today Jean is best remembered for his collecting. As the art historian Roger Wieck observes, 'he stands out as *the* collector of the Middle Ages. Art and pleasure mad, he

amassed castles, jewels, dogs, tapestries, objets d'art, boys (if Michael Camille is to be believed) and illuminated manuscripts'. The January miniature in the *Très Riches Heures*, one of his great manuscripts, shows the duke at his table surrounded by finely dressed servants, rich tapestries and goldsmith's work (Fig. 20).

Jean's many fine castles included those at Bourges, Mehun-sur-Yèvre, Nonette, Dourdan and Bicêtre, which are recorded in the illuminated calendar pages of the *Très Riches Heures*. His favourite residence in Paris was the Hôtel de Nesle, whose foundations now lie under the Institut de France. His tapestries were numerous, and his inventories record that his jewels were equally luxurious, comprising cameos, enamels, brooches with gems, rings without number, little reliquaries and little crosses to hang about the neck, paternosters of gold and other material. He had a large collection of relics: the marriage ring of the Virgin, the body of an innocent murdered by Herod, a cup of yellow marble that was used at the marriage at Cana, one of the stones that Christ changed into bread in the desert,

21 The base of the Holy Thorn Reliquary showing the arms of Jean, duc de Berry.

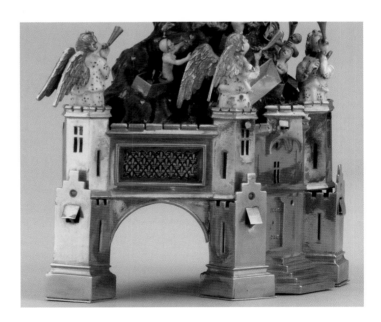

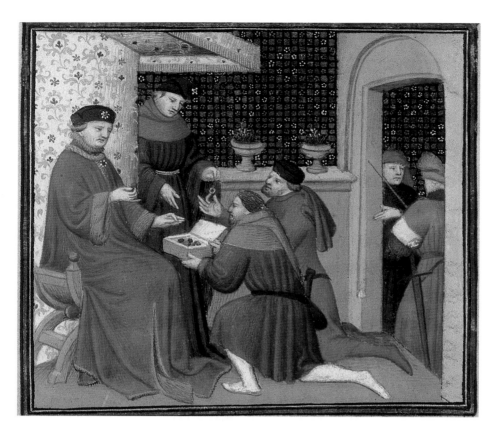

22 Jean, duc de Berry(?), examining precious stones. From the *Livre des Propriétés des Choses*, book XVI. Illuminated by the Boucicaut Master, c. 1410. Bibliothèque nationale de France

part of the grill of St Laurence, a fragment of the burning bush and a part of the cloak of Elijah. Of his great collections very little survives.

Above all, Jean was a collector of precious stones. He had at least sixteen exceptional rubies, some of which were known by special names such as the King of Rubies, the Burgundy Ruby, the Berry Ruby and the Heart of France. Some of them were valued at enormously high sums. He had many other precious stones such as diamonds, pearls, sapphires and emeralds; semi-precious stones such as agates, garnets, chalcedony, amethysts and rock crystal; and stones that were often thought to be amuletic, such as toadstones, porphyry, amber and coral. Many were set in large pieces of goldsmith's work.

A tabernacle, over a metre high, was decorated with images of the Trinity and the Annunciation, St George and St Michael, four angels and portraits of the duke and duchess, the whole decorated with 64 balais rubies or spinels, 2 rubies, 47 sapphires, 2 diamonds and 226 pearls. By comparison the Holy Thorn Reliquary is modest in its use of stones, but the fact that the thorn is elaborately framed with precious stones, especially rubies, is no surprise. A manuscript illustration shows a prince, most probably Jean, admiring precious stones (Fig. 22); it is said that he would break off from important business when a dealer in precious stones arrived.

Jean's religious beliefs

Although a worldly figure of great magnificence, Jean, duc de Berry, was concerned with religion, with the need for divine protection in this life and preparation for the life to come, and for his burial and tomb (Fig. 23). As a royal prince he was devoted both to St Denis and to the Sainte Chapelle in Paris. In 1372 his brother Charles V gave him a fragment – cut off with his own hands – from the relic of the True Cross, which was kept in the Sainte Chapelle. In 1388 an agreement was made by the canons of the Sainte Chapelle to celebrate for the duke a mass of the Holy Spirit to be held annually on 10 September (this date may have been chosen since it was next to that of the death of his mother, Bonne of Luxembourg, in 1349). After Jean's death, it was converted into an annual mass for his soul.

Jean's preparations for his own tomb are linked with the creation of his Sainte Chapelle. He first thought about his tomb in the early 1390s and wanted a splendid monument in the choir of Bourges Cathedral. After the canons of the cathedral objected, he obtained permission to construct a large chapel – a Sainte Chapelle – attached to his palace at Bourges in 1392 (see Fig. 11). The chief relic was to be the fragment of the True Cross that he had received from the Sainte Chapelle in Paris, but he was eventually to endow his own Sainte Chapelle with more relics, jewels and ornaments than were in the Paris Sainte Chapelle when St Louis died. The chapel, independent of the cathedral, owed something to the example of Philip the Bold, who had built

a Carthusian monastery (or Charterhouse) at Champnol, near Dijon, in which he intended to house the tombs of his family. This had been consecrated in 1388. Philip's death in April 1404 moved Jean to order the completion of the Sainte Chapelle at Bourges, which was consecrated in April 1405. His own funerary monument, carrying his effigy (Fig. 24), was sculpted by Jean de Cambrai, but may not have been finished by the date of his death. The duke died in Paris on 15 June 1416 and his body was brought to Bourges in great style to be buried in his Sainte Chapelle. Ironically, the tomb has survived because it was moved into the cathedral in the mid-eighteenth century, when the Bourges Sainte Chapelle was demolished.

The duke's inventories

The two major inventories of the collections of Jean, duc de Berry, are extraordinarily detailed. The first was begun in 1401 at Paris, moved on to the chateau at Mehun-sur-Yèvre and concluded in 1403 at Bourges. It contains valuable notes dating from 1404 to 1407 that relate to gifts made by the duke to the Sainte Chapelle at Bourges. Robinet d'Étampes, the keeper of the collections and compiler of the inventories, was thorough and precise in his work.

There is nothing in the inventories that can be certainly identified with the Holy Thorn Reliquary. One possibility is that the reliquary had been made, enjoyed and given away by the duke before the inventory was begun. The reliquary's probable date of manufacture around the end of the fourteenth century makes this entirely likely. However, there is an alternative possibility. The British Museum curator Hugh Tait pointed out that item 10 of the 1401–3 inventory refers to a gold imperial crown (a crown closed at the top), in the fleurons (upstanding fleurs-de-lis) of which were set four thorns from the Crown of Thorns. It was impressively bejewelled with twelve large rubies and eight small ones, seventeen large sapphires, eight small emeralds, twenty-six large pearls and forty other lesser pearls. An addition to the inventory tells us that this crown was broken up on the order of the duke, with the gold delivered to his treasurer and the gemstones to the duke himself, who later

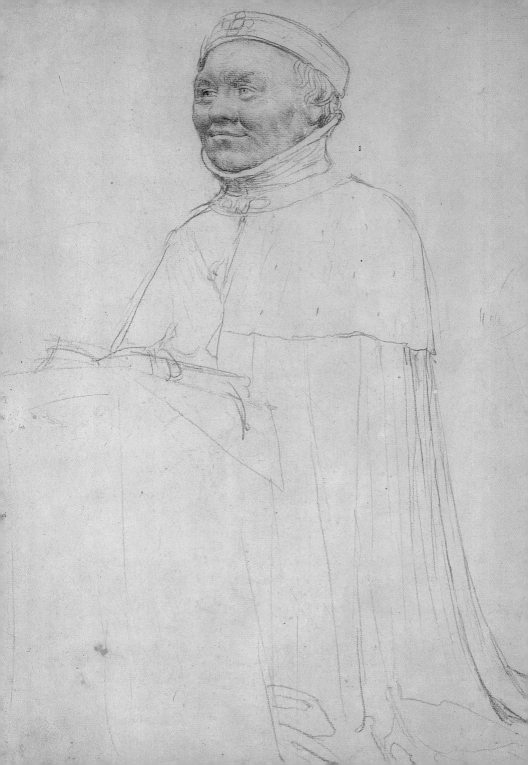

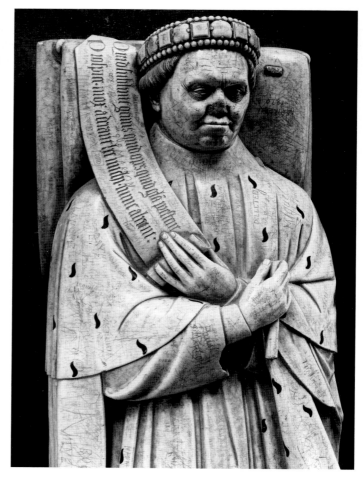

gave six emeralds to the Sainte Chapelle at Bourges. The other gems were given to a goldsmith, Renequino de Hallen, to make a gold '*jocali*' – jewel or reliquary – containing one of the four thorns, the other three being given to the Sainte Chapelle at Bourges. These were set in a crown, which was preserved in the Treasury of the Sainte Chapelle and recorded in a drawing by Dr John Bargrave, an English traveller, in the seventeenth century.

It is possible that this '*jocali*' is the Holy Thorn Reliquary and that it was made by Renequino de Hallen. However,

there are two difficulties with this interpretation. The first is that the arms on the plaques are those used by the duke before 1397. Although he later used his old arms on occasion, it is unlikely that he would have done so on a work first created after that date. The second problem is that the style of the reliquary more satisfactorily fits a date before 1397. The reference in the inventory may have nothing to do with the present reliquary, because it may have been given away before the 1401–3 inventory was compiled.

New Year's gifts

That Jean should give away an object containing a relic and bearing his arms can be better understood in the light of the fact that offering gifts, especially at the New Year, was an important ritual at the Valois courts of Charles VI and Charles VII. Known in French as *étrennes* (from the Latin *strena* – portent – since they were to be good signs for the coming year), such gifts were used to affirm bonds between members of the royal family, their supporters and their servants. According to the historian Jan Hirschbiegel, 6,403 actual gifts are recorded at the Valois courts for the period between 1381 and 1422, but the real figure must have been far higher. Between 1401 and 1416 Jean, duc de Berry, purchased and commissioned for himself 119 objects compared to the 358 that he received as gifts from as many as twenty individuals, more than half of which were given as *étrennes*. He in turn distributed some 231 gifts at least. The figure of St Michael (see Fig. 14), now only known from a painting, was one of the finest examples of such an *étrenne* gift, and bears some similarities to the Holy Thorn Reliquary.

The loss of the duke's collections

The duke was seventy-six years old when he died. It was fortunate that he did not live longer and have to witness the victorious English melting down gold works of art in Paris on 30 July 1417. One of the finest pieces lost then was the gold and silver *nef* (a table piece made in the form of a ship) of Charles VI, which showed, beside St Louis and Charlemagne, the Annunciation, twelve apostles, four

evangelists, the crucifix surrounded by angels holding the instruments of the Passion, and God the Father, not to mention Adam and Eve with God the Father, the Archangel Michael and the serpent, all amid a profusion of precious stones. Saddest of all for Jean would have been the melting-down of the gold cross which had been one of the greatest and most precious pieces in his collections. Jean had offered it to Charles VI eight days before he died, beseeching the king that he should never be separated from it.

For us it is an extraordinary piece of good fortune that, by giving away the Holy Thorn Reliquary, the duke enabled its survival. That it can be seen today in the galleries of the British Museum is one of the accidents and chances of history.

The duc de Berry was a great patron of illuminated manuscripts and the Holy Thorn Reliquary can be seen as a painting in gold and enamel. With its solemnity and beauty it evokes the fear of death and the hope of salvation through Christ. We do not know the setting in which the reliquary stood. It may well have been on the altar of a private chapel, in which the altarpiece may have been a Crucifixion or possibly a painting of the Christ in Pity, both of which would have augmented the association of the relics with the sacrifice of Christ. It may have been used as an aid to prayer to alleviate the pains of Purgatory and so developed – through the help of the Veronica, St Michael and St Christopher – a protective quality. It is a piece of miniature sculpture that creates an image, using the iconography and style of paintings, which would assure the duke of his salvation through the sacrifice made by Christ in his Passion and Crucifixion:

Requiem eternam dona eis domine
Et lux perpetua luceat eis.
(O Lord give them eternal rest
And let light perpetual shine on them.)

Chapter 5
The faker revealed

We do not know when the Holy Thorn Reliquary left the
possession of the duc de Berry, but its very survival
indicates that it had left his collections before 1415. It may
have been given away before the first of his inventories was
written in 1401–3. A strong possibility is that it was
presented as a gift to a member of his brother Philip the
Bold's family, before Philip's death in 1404. Many gifts were
exchanged between the brothers. The manuscript of the
Très Belles Heures, completed in late 1402, on which the duc
de Berry had lavished much time and expense, was soon
given away to Philip. It then passed to his son John the
Fearless and, on John's death, to his wife, Margaret of
Bavaria. Margaret was particularly devoted to St Veronica
and the Holy Face, which could be invoked against the
danger of sudden death. She may have added the Veronica
on leather that is stuck into the *Très Belles Heures*, and she
may have added Veronicas to the prayer book of Philip the
Bold. If the Holy Thorn Reliquary was in the possession
of the Burgundian family, Margaret might well have
instigated the changes made to the back and the addition
of the Veronica. If this was the case, it makes it very likely
that the original fabric within the back showed a Veronica.

Whatever the circumstances of its departure from the
duke, the reliquary appears in 1544 in the possession of the
Spiritual Treasury (Geistliche Schatzkammer) of the
Habsburg emperors in Vienna. How it went from Paris to
Vienna is a subject of speculation. A number of fifteenth-
century courtly objects that once belonged to the
Burgundian family went to Vienna, mainly through the
marriage in 1477 of Mary of Burgundy, daughter of Charles
the Rash (Duke of Burgundy from 1467 to 1477), to the
Archduke Maximilian of Austria, who in 1508 became Holy
Roman Emperor.

The reliquary remained in the Geistliche Schatzkammer
until the 1860s, when it was sent for restoration, with four
other objects, to Salomon Weininger, a resourceful and

well-connected antique dealer. Weininger was not a craftsman himself but employed a number of craftsmen in Vienna to produce replicas of all five works. He sent these back to the Schatzkammer, and kept the originals himself. How he disposed of them is not known. In June 1876 Weininger was arrested and tried, not for this forgery but for other forgeries in Vienna. He died in an Austrian state prison in 1879.

The copy of the reliquary produced between 1863 and 1872 has many differences from the original (Fig. 25). The major changes were, on the front, the addition of decorative enamelled features such as a blue door and green leaves around the apostles. At the back the figures of St Michael and St Christopher were enamelled in lurid red and blue clothes against a golden ground. There are decorative flowers and leaves added at the back, while the face of Christ behind God the Father is missing entirely. These changes tell us more about Weininger's craftsman than the original state of the reliquary. It is possible that the thorn in the original reliquary may have been replaced at this time.

The Holy Thorn Reliquary was acquired by Anselm von Rothschild, head of the Vienna branch of the Rothschild bank, by 1872, when it appears in the supplement to the catalogue of his collections. We do not know whether he acquired it directly from Weininger or through another dealer. On Anselm's death in 1874 it was left to his son Ferdinand (Fig. 26). Ferdinand disliked both Vienna and banking, and so came to England, where he married his wife, Evelina. After her death in childbirth in 1866, Ferdinand lived as a rich widower, passionately devoted to hunting and collecting, especially French furniture and English paintings. In his Victorian way Ferdinand emulated Jean, duc de Berry. He built Waddesdon Manor in Buckinghamshire – modelled on the chateaux of the Loire – where the reliquary was displayed in the smoking room, amid works that Ferdinand had inherited from Anselm and others that he had acquired himself. Ferdinand amassed an outstanding collection, part of which he left in 1898 as a bequest to the British Museum. He may have been

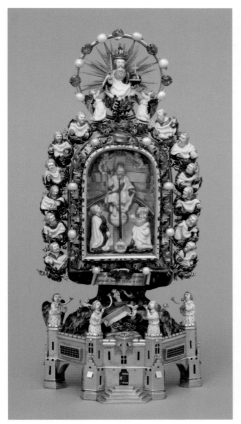
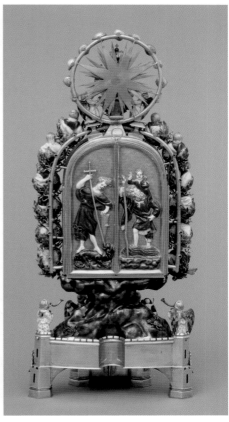

25 The copy of the Holy Thorn Reliquary made to the order of Salomon Weininger in the late 1860s and returned to the Schatzkammer in place of the original. Kunsthistorisches Museum, Vienna

influenced in this by Sir Augustus Wollaston Franks, then Keeper of British and Medieval Antiquities at the Museum, who, among much else, had been responsible for the purchase of the Royal Gold Cup for the Museum (see Fig. 12). Franks died in 1896, Ferdinand in 1898.

Today the Holy Thorn Reliquary holds a prominent place in the British Museum as part of the Waddesdon Bequest, which is displayed as one of the great collections of the nineteenth century. The true history of the reliquary was not understood until 1925, when the art historian Joseph Destrée demonstrated that the work in Vienna was a copy and the one in the British Museum was the original. The correct identification of the person represented by the

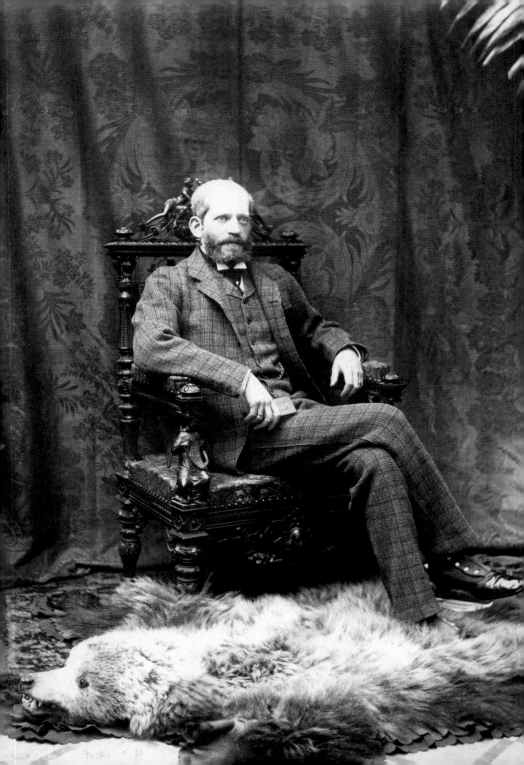

heraldry, and thus the patronage of Jean, duc de Berry, was only made by the British Museum curator Hugh Tait in 1962.

The reliquary's survival – from its creation in Paris at the end of the fourteenth century, through the English occupation of France during the Hundred Years War, its passage to Vienna, and from there to a public collection in England – is a remarkable story. It can now be appreciated by all as a great work of the goldsmith's art reflecting the devotional attitudes of its time, the fear of death and the hope for resurrection and salvation through the body and passion of Christ.

Further reading

The best detailed description of the Holy Thorn Reliquary is by Hugh Tait, *Catalogue of the Waddesdon Bequest in the British Museum, 1: The Jewels*, London 1986, pp. 26–46. Suggested further reading on the individual chapters of this book is listed below.

Chapter 1: The Sight of Salvation
Gabriele Finaldi, ed., *The Image of Christ*, London 2000

Marie-Madeleine Gauthier, *Highways of the Faith: Relics and Reliquaries from Jerusalem to Compostela*, transl. J.A. Underwood, London 1986

Flora Lewis, 'Rewarding Devotion: Indulgences and the Promotion of Images', in D. Wood, ed., *The Church and the Arts*, Oxford 1992, pp. 179–194

Henk van Os, *The Way to Heaven: Relic Veneration in the Middle Ages*, Baarn 2000

Chapter 2: The Crown of Thorns
Le trésor de la Sainte-Chapelle, exh. cat. Musée du Louvre, Paris 2001

François de Mély, *Exuviae sacrae Constantinopolitanae III*, Paris 1904

Chapter 3: The goldsmith
For the Royal Gold Cup, see O.M. Dalton, *The Royal Gold Cup in the British Museum*, London 1924; *Les Fastes du Gothique: Le siècle de Charles V*, exh. cat. Grand Palais, Paris 1981–2, no. 213; Jenny Stratford, *The Bedford Inventories. The worldly goods of John, Duke of Bedford, Regent of France (1389–1435)*, London 1993, pp. 319–25

Eva Kovács, 'Problèmes de style autour de 1400. L'orfèvrerie parisienne et ses sources', *Revue de l'art* 28 (1975), pp. 25–33

For several of the pieces of white enamel described, see *Paris 1400: Les Arts sous Charles V*, exh. cat. Musée du Louvre, Paris 2004, and Eva Kovács, *L'âge d'or de l'orfèvrerie parisienne au temps des princes de Valois*, Dijon 2004

For the craftsmen, see Rob Dückers and Pieter Roelofs, eds, *The Limbourg brothers: Nijmegen masters at the French court, 1400–1416*, exh. cat. Museum Het Valkhof, Nijmegen 2005

T. Müller and E. Steingräber, 'Die französische Goldemailplastik um 1400', *Münchner Jahrbuch der bildenden Kunst* V (1954), pp. 29ff., no. 3

Das Goldene Rössl: Ein Meisterwerk der Pariser Hofkunst um 1400, exh. cat. Bayerisches Nationalmuseum, Munich 1995, esp. the essay by Neil Stratford, 'De opere punctili. Beobachtungen zur Technik der Punktpunzierung um 1400', pp. 131–45

Chapter 4: Jean, duc de Berry

For the duke, see Millard Meiss, *French painting in the time of John de Berry. The late fourteenth century and the patronage of the Duke*, London and New York 1967

For his life, see F. Lehoux, *Jean de France, duc de Berri, sa vie, son action politique 1340–1416*, Paris 1966–8

For his inventories, see J. Guiffrey, *Inventaires de Jean, duc de Berry (1401–1416)*, I. *Inventaire de 1413 (A)*, Paris 1894; II. *Inventaire de 1403 (B) et autres inventaires*, Paris 1896

For his Sainte Chapelle, see *La Sainte-Chapelle de Bourges*, exh. cat. Musée du Berry, Bourges 2004

For *étrennes*, see Brigitte Buettner, 'Past Presents: New Year's Gifts at the Valois courts ca. 1400', *Art Bulletin* 83 (December 2001), pp. 598–625

Chapter 5: The faker revealed

For Ferdinand Rothschild, see D. Thornton, 'From Waddesdon to the British Museum', *Journal of the History of Collections*, 13, no. 2 (2001), pp. 191–213

The most recent and exhaustive study of Salomon Weininger is by Paulus Rainer, 'Es ist immer dieselbe Melange: der Antiquitätenhandler Salomon Weininger und das Wienerkunstfälscherwesen im Zeitaltar des Historismus', in *Jahrbuch des Kunsthistorischen Museums Wien, Band 10*, Mainz 2008, pp. 29–99. He is also discussed in J.F. Hayward, 'Salomon Weininger, Master Faker', *Connoisseur* (November 1974), pp. 170–79

Waddesdon Manor, the home of Ferdinand Rothschild, is open to the public and well worth visiting. See www.waddesdon.org.uk.

Image credits

Every effort has been made to trace the copyright holders of the images reproduced in this book. All British Museum photographs are © The Trustees of the British Museum.

1 Photo: British Museum; P&E Waddesdon Bequest 67. Bequeathed by Baron Ferdinand de Rothschild
2 Photo: British Museum
3 Bibliothèque nationale de France, Paris, MS Lat. 18014, fol. 106
4 Photo: British Museum
5 National Gallery of Art, Washington DC, Widener Collection, 1942.9.287; © photo: Philip A. Charles
6 Photo: British Museum
7 Photo: British Museum
8 Rijksmuseum, Amsterdam, inv. no. RBK-17045
9 Bibliothèque nationale de France, Paris, MS nouv. acq. Lat. 3145, fol. 102
10 Photo: British Museum; P&E 1902,0210.1. Given by George Salting
11 Bibliothèque nationale de France, Paris, Département des Estampes, Ub.9 res, fol. 46
12 Photo: British Museum; P&E 1892,0501.1. Acquired with contributions from HM Treasury, the Worshipful Company of Goldsmiths, Sir Augustus Wollaston Franks and others
13 Photo: British Museum

14 Bayerisches Nationalmuseum, Munich, inv. no. MA 2607
15 Photo: British Museum; P&E 1966,0703.1. Purchased with contributions from the Art Fund, the Pilgrim Trust and the Worshipful Company of Goldsmiths
16 Musée du Louvre, Paris, inv. no. MR 552; © photo RMN / Jean-Gilles Berizzi
17 Museo Sistino Vescovile, Montalto, Marche, Italy
18 Photo courtesy of the Bridgeman Art Library
19 Photo: British Museum
20 Musée Condé, Chantilly, MS 65, fol. 1v; © RMN / René-Gabriel Ojéda
21 Photo: British Museum
22 Bibliothèque nationale de France, Paris, MS Fr 9141, fol. 235v
23 Kunstmuseum Basel, Kupferstichkabinett, inv. no. 1662,125; photo: Martin P. Bühler
24 Photo courtesy of the Courtauld Institute, London
25 Kunsthistorisches Museum, Vienna, inv. no. GS D 129
26 National Portrait Gallery, London, NPG Ax15704